Henry Pearson
The Poetry of Line

Patrick J. McGrady

PALMER MUSEUM OF ART
THE PENNSYLVANIA STATE UNIVERSITY
UNIVERSITY PARK, PENNSYLVANIA

September 11-November 18, 2001

LOUISE WELLS CAMERON ART MUSEUM
WILMINGTON, NORTH CAROLINA

February 27-May 25, 2003

Cover: Study No. I for Lincoln Center New York Film Festival Poster, 1968.
Ink and graphite on paper, 22 7/8 x 15 inches (image), 23 7/8 x 16 1/4 inches (paper).
Collection of the artist.

Back Cover: Study No. II for Lincoln Center New York Film Festival Poster, 1968.
Ink and graphite on paper, 22 7/8 x 15 1/8 inches (image), 23 1/16 x 15 7/16 inches (paper).
Collection of the artist.

ISBN 0-911209-54-9 Library of Congress Control Number 2001 135282

Designed by Catherine H. Zangrilli
Art photography by the Image Resource Center at Penn State
Printed by Commercial Printing, State College, PA

This publication is available in alternative media on request.

The Pennsylvania State University is committed to the policy that all persons shall have equal access to programs, facilities, admission, and employment without regard to personal characteristics not related to ability, performance, or qualifications as determined by University policy or by state or federal authorities. It is the policy of the University to maintain an academic and work environment free of discrimination, including harassment. The Pennsylvania State University prohibits discrimination and harassment against any person because of age, ancestry, color, disability or handicap, national origin, race, religious creed, sex, sexual orientation, or veteran status. Discrimination or harassment against faculty, staff or students will not be tolerated at The Pennsylvania State University. Direct all inquiries regarding the nondiscrimination policy to the Affirmative Action Director, The Pennsylvania State University, 201 Willard Building, University Park, PA 16802-2801. Tel (814) 865-4700/V, (814) 863-1150/TTY. U.Ed. ARC 02-33

PENNSTATE

1855

College of Arts and Architecture

Acknowledgements

This exhibition came to fruition through the infectious enthusiasm of Terry Duffy, a long-time student and close friend of Henry Pearson. In early 1999, the Palmer Museum of Art received from Terry and her husband Ed a magnificent 1972 painting by Pearson, titled *Consecration*. At the time of the gift, Terry proposed that the Palmer Museum organize an exhibition of drawings, based on a selection from the assortment of works on paper she had gathered for safekeeping from the artist's studio. We wholeheartedly agreed to the project, which nearly doubled in scope in the spring of 2001 with a second gift from the Duffys of over forty additional works by Pearson. For Terry's unwavering patronage we are most grateful.

Mary Jane Harris, forever a friend and advocate of the museum and its programs, deserves recognition for her work, often behind the scenes, in helping to ensure the success of this exhibition. And we are indebted to three current and former students of Henry's: Carole Barlow; Patricia Hagood, founder and publisher, Oxymoron Media, Inc.; and George Wingate, adjunct professor in the Department of Visual Arts at Gordon College, for providing information, ideas, and stimulating conversation about Henry and his art. An additional word of thanks goes to George Wingate for lending several drawings to the exhibition.

We would like to express our gratitude to Will Barnet and Larry Dubin for their support and encouragement of this project. Several individuals from other institutions were responsible for providing images and resource material, including Anne Brennan, registrar and curator at the Louise Wells Cameron Art Museum; Libby Chenault in the Rare Book Collection, Wilson Library, University of North Carolina, Chapel Hill; Thomas Douglass, assistant visiting professor, Department of English, East Carolina University; Marcia Erickson, assistant registrar at the North Carolina Museum of Art; Evie Joselow; Michael McGrady at Christie's, New York; and Gary Weathersbee, videographer, University Relations, East Carolina University.

As always, the staff at the Palmer Museum of Art has contributed significantly to the organization of the exhibition and preparation of its catalogue, in particular, Patrick McGrady, Charles V. Hallman Curator. Patrick was also ably assisted by Betsy Warner, Barbara Weaver, Rich Hall, Ron Hand, Beverly Sutley, Jennifer Noonan, and Julia Dolan.

The exhibition has been funded in part through a generous grant from The Richard Florsheim Art Fund established by artist Richard Florsheim and his wife Helen. The fund supports projects that provide recognition for senior American artists of merit.

A very special thank you goes to Henry Pearson, for providing selfless access to his studio and archives, for enduring countless inquiries with grace, humor, and endless patience, and for producing, over the span of more than forty years, a body of drawings that has made the organization of this exhibition a rich and rewarding experience for all involved. Finally, as we were about to go to press, Henry notified us of his intention to give to the Palmer Museum of Art a large number of his drawings and prints, many of which are included here.

Jan Keene Muhlert, *director*
Palmer Museum of Art

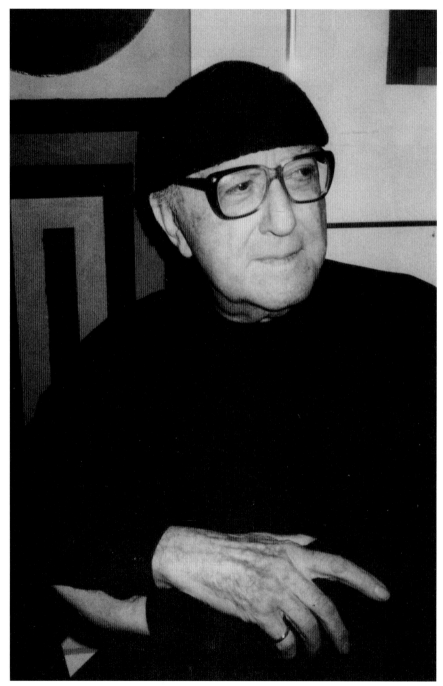

Henry Pearson in his studio, 1996. Photograph by Patricia Hagood. Copy courtesy of The Rare Book Collection, The University of North Carolina at Chapel Hill.

The Poetry of Line
Drawings by Henry Pearson

Draw lines, young man, many lines; from memory or from nature,
it is in this way that you will become a good artist.[1]

By the time Henry Pearson had determined that art was to be his profession, the conditions under which Jean-Auguste-Dominique Ingres offered the above counsel to a twenty-year-old Edgar Degas had, of course, changed considerably. Ingres was speaking as one of the principal defenders of a highly hierarchical academic tradition—already ensconced in France for over two centuries and rooted in the aesthetic programs of Renaissance Italy—for which drawing stood as the foundation. In Pearson's day, drawing had long been relieved of its conventional roles, obtaining through successive generations of modernism's avant-garde a level of independence unimaginable to Ingres. Still, similar words might have had some bearing when, toward the end of 1959, Pearson felt compelled to set down his thoughts on drawing in a letter:

> A drawing is a picture accomplished by placing (usually) one color by *any* means, such as brush, pen, charcoal, pencil, in a linear manner on a plain surface which may or may not be tinted. It differs from a "sketch" in that it is usually intended to be a finished product, whereas a "sketch" is a rapidly accomplished note for future study or advancement in the form of a painting, or filing as random information.[2]

Offered in response to a query on the part of his parents, who evidently were wondering about their son's newly discovered interest in putting ink to paper, the description is remarkable only when considered in the context of the recent turn of events that had occurred in Pearson's work. The key points to contemplate are the generous parameter he allowed for the medium—it could consist of one color placed in any way upon any unadorned surface, as long the mark was made in a linear manner—and the effort he made to differentiate a drawing from a sketch.

Pearson had then been living in New York City for six years. When he first arrived, in 1953, to begin his training at the Art Students League, the art world was flush with Abstract Expressionism. For the artists of this group, drawing was as autonomous as painting, an independent medium subject to the same immediacy of expression as their canvases. Indeed, for Jackson Pollock at least, drawing and painting were essentially synonymous. "I approach painting in the same sense as one

approaches drawing;" he said during an interview in the fall of 1950, "that is, it's direct. I don't work from drawings, I don't make sketches and drawings and color sketches into a final painting."[3] To work from a sketch suggested a preconception in the process, and such notion would have been contrary to the desired spontaneity.

Initially captivated by realism, Pearson wasn't immediately interested in the Abstract Expressionist aesthetic, and while at the Art Students League he employed drawing in a somewhat traditional manner. He worked from the model, turning out both quick studies and finished treatments, and for years he dutifully recorded his surroundings for future reference in omnipresent sketchbooks. When his painting turned to geometric abstraction, his preferred style for a good part of the 1950s, his compositions were frequently developed first in pencil sketches fleshed out with watercolor. In 1959, however, his painting had reached something of an impasse, and for most of that year he experimented with paper and pen in a wholly new direction. The effort resulted in a contoured linear abstraction that might most accurately be categorized as internal landscape. These were the drawings he was writing home about, and what *was* remarkable about them was that for the first—and only—time in Pearson's career, they achieved a status above that of sketch or study, standing alone as complete, albeit relatively intimate, statements. The idea turned out to be incredibly fertile for Pearson, and, readily voiced on canvas and in print as well, it dominated his work for the next fifteen years.

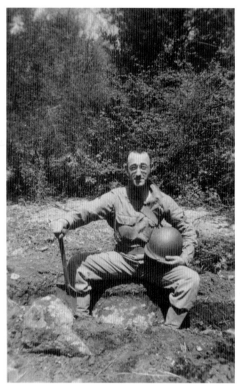

Fig. 1. Henry Pearson in the U.S. Army, on maneuvers in Tennessee, 1943.

The visual arts were not Pearson's first career choice. A native of Kinston, North Carolina, he enrolled in the University of North Carolina, Chapel Hill, in 1931, with thoughts of becoming a doctor. His pre-med classes, however, could not compete with the stage, and, despite the fact that UNC didn't have a drama program, he convinced the administration to put together a course of study for him in theatre design. Upon graduation in 1935, he headed straight for Yale University's School of Drama to work with famed set designer Donald Oenslager, and within three years he received his M.F.A. For his Master's thesis, he designed Eugène Coralli's ballet *Le diable boiteux*. The costume sketches (cat. no. 1) are among his earliest extant drawings.

Pearson's first professional position after Yale was as a scene painter for the Matunick Theater in Rhode Island. Consecutive postings as a stage designer for the Roadside Theater in Bethesda, Maryland; the Civic Theater in Washington, D.C.; and the Dock Street Theater in Charleston, South Carolina, followed. By the time he moved to Charleston, war was dangerously close. He was called up in 1941, but was rejected due to poor eyesight. Brought in a second time in the spring of 1942, he passed the physical, and was drafted into the U.S. Army. After a year of lettering signs and draw-

ing anatomical diagrams for a medical corps in Florida and maneuvers in Tennessee (fig. 1), he was sent to Dayton, Ohio, where he created set designs for movies produced by the Army. He then was shipped to the Hal Roach Studios in Culver City, California, to work in the art department of a unit that made training films for Army Air Force flyers. His most significant project there—and one of the most clandestine of the war—involved developing interpretive contour drawings after secret Japanese Imperial survey maps (cat. nos. 2 and 3). By November of 1944, U.S. forces had retaken sufficient territory in the Pacific to allow their bombers to strike the main Japanese islands on a regular basis. Pearson's drawings enabled the construction of three-dimensional scale models of vast areas of Japan. On a scale of one foot equals one mile, as many as 10,000 square miles of Japanese topography were recreated in the studio at one time. Each model was filmed from above, as though from an airplane, providing prototypical bombing runs for U.S. pilots to study.

Scrutinizing a country so intimately on the surface piqued Pearson's interest. After the war, he enlisted as a medic for another tour of duty with the request to be stationed in Japan. In 1946, he was sent to Okinawa, where he worked as a file clerk in a medical dispensary, and a year later he was reassigned with similar administrative duties to a hospital in the city of Tachikawa, about twenty miles west of Tokyo. Pearson took advantage of every opportunity to absorb the Japanese culture. His letters record detailed observations on festivals, religious ceremonies, and excursions to ancient shrines and temples, particularly in the vicinity of Kyoto. The richest reports center on his many visits to the Noh theatre with Shozo Yamamoto, the head of one of the leading intellectual societies in Tokyo. Initially, these experiences provided source material for costume designs he hoped to use when he returned to the States. *Ininawa*, for example (cat. no. 4), reflects an amateur performance by local townspeople he witnessed in Okinawa. *Zekai* (cat. no. 6) is a watercolor sketch of the *shite*, or main character, in a *kiri-noh-mono* (last piece) of a Noh program. *Beshibari* (or *Boshibari*, literally "fastened to a bar," cat. no. 5) depicts the servant Taro-kaja in the title role of a Kyogen—a comical interlude performed between two Noh dramas.

The fascination with these characters encouraged Pearson to attempt to recreate them in a Japanese manner, and he began to experiment with *shkishi*, a traditional Japanese painting executed on eight-by-nine inch gold-edged boards primed for watercolor. He got in the habit of bringing his *shkishi* studies along with him during visits to the Mizusaki gallery in Tokyo, where he had previously deposited one of his *sumi-e* to be framed.[4] Pearson tells an illuminating story regarding the experience:

> Mizusaki, who at the time must have been about seventy-five years old, spoke no English, so my conversations with him were interpreted by his son. Among the first *shkishi* I brought in was an opening scene from the Noh play *Kantan*, depicting a young Chinese man walking in the snow toward a hotel. Mizusaki recognized the theme, and admired the snow, then politely shook his head, saying, "but it isn't Japanese." This went on for several months, with the same results. They were all very good, but, according to Mizusaki, none possessed the proper tone to

pass as Japanese. One day, while visiting the shrine near Nikko, I observed in the distance a temple located half-way up one of two steep mountains, each surrounded by clouds at their peaks. Upon returning to the hospital, I immediately recorded the scene as a *shkishi*, and brought it to Mizusaki. When the old man saw it, he sucked up his breath in appreciation. With his long white finger he circled the clouds, and in English said, "This is Japanese!" (He didn't want anyone knowing that he knew English, but from that day he spoke in English with me, and from then on, all of my *shkishi* were Japanese for Mizusaki.)

I then took the *shkishi* home to my quarters, laid it on the floor, set up paints and brushes, and attempted to recreate what had happened that made those few square inches of the painting Japanese. All of a sudden, for no particular reason, the sensation of a cool ocean wave washed over me, and as it did, I realized that I was going to paint for the rest of my life.[5]

To embody this perception, Pearson thought it best to remain in Japan, so late in 1949 he re-enlisted for another tour of duty. Unfortunately, the Air Force had other plans,[6] and shipped him to Eglin Air Force base in Florida, where he spent his final three years in military service involved once again with movie production. As often as possible he would journey to New York City, which for several years prior to his return to the United States he had considered as the ideal location for his artistic training. While in Japan, he had read in the local newspapers about Yasuo Kuniyoshi, whose praise for the Art Students League impressed Pearson. Upon his discharge in March of 1953, he moved immediately to Manhattan and registered with the League.

Pearson chose to study painting with Reginald Marsh. He knew Marsh's work, enjoyed it, and on the day he enrolled for classes, he thought Marsh "looked to me like the kind of person who could teach one how to paint and not be too concerned about what is painted."[7] He was partly right, finding Marsh to be a fair teacher but distinctly dispassionate about abstraction.[8] The opinion, of course, was for the moment of little concern to Pearson, for he was quite content to receive the kind of professional instruction that would enhance his ability to capture nature in a manner related to the work he had done while in Japan. Under Marsh's tutelage, he fell comfortably into a representational manner of painting, favoring landscapes with figures. His sketchbooks and studies of that year detail his progress, and often contain corrective remarks in Marsh's hand (fig. 2). For life drawing, he selected Robert Ward Johnson, whose book illustrations he admired and whose preference for crisply delineated form Pearson adopted for his own figure studies (cat. nos. 7 and 8).[9]

The following year, while continuing with Marsh, Pearson signed on for additional painting classes with Will Barnet, whom he found to be a superior teacher. At the time, Barnet's post-cubist approach was nearly diametrically opposed to Marsh's; however, Pearson discovered that both men were attracted to the same qualities in a painting. While they may have disliked one another's style, when it came to formal considerations—composition, weight, harmony of color, balance, etc.—

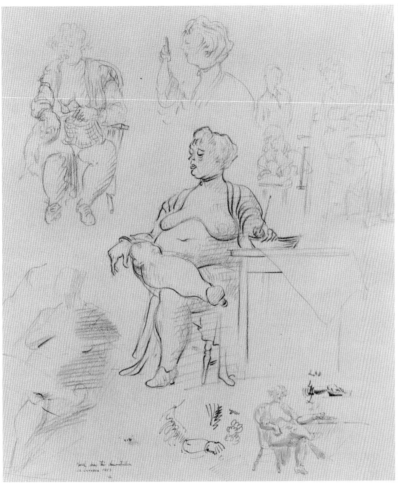

Fig. 2. Henry Pearson, drawing in Reginald Marsh class, 1953. Pencil and ink, 17 x 14 inches. Signed in lower left: "Marsh drew this demonstration 22 October, 1953—H." Marsh's drawing is in the lower left; the remaining studies are by Pearson. North Carolina Museum of Art, Raleigh, gift of Henry Pearson. Photograph courtesy of the North Carolina Museum of Art.

they were in complete agreement.[10] The concurrence between the two artists served as Pearson's most significant lesson as a student. Regardless of orientation, abstract or realistic, certain characteristics were common to all successful works of art. The idea facilitated his shift into abstraction, which occurred that same year. The immediate spark came when he encountered a Suprematist composition by Kasimir Malevich at an exhibition in the Rockefeller Guest House on East 52nd Street.[11] At his easel the next day, the transcription of nature gave way to bold non-representation. The first efforts derived strongly from Malevich; however, Pearson soon evolved an individual style that featured sophisticated arrangements of rectilinear forms. It became his first mature voice, and functioned as his principal mode of expression for the remainder of the decade.

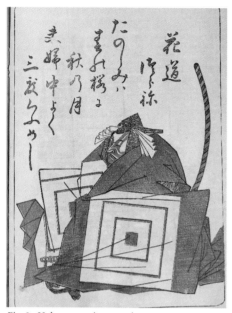

Fig. 3. Unknown artist, actor in a *Shibaraku* role, in Seien Kitao, *Azuma Kyoka Bunko* (*A Book of Japanese Comical Poems*). Tokyo, 1781-86. Color woodblock print, 8 1/4 x 5 7/8 inches (image; page size 10 1/2 x 7 1/8 inches). Photograph by Noel Allum.

As he settled into geometric abstraction during the mid-1950s, Pearson created a consistent body of preparatory sketches and studies that record the development of his oeuvre from idea to painting (cat. nos. 9-11). And although he has declared his paintings of this period to be wholly non-objective, claiming they arise out of the same abstract thought as music,[12] in the studies one can often discern sources that approach the mundane. Such is the case with the preliminary drawing for *Demon F.S.P. #22* (cat. no. 9). The two red and white labyrinths in the upper center and lower left, and the brown rectangular pattern dominating the center of the composition, derive from an illustration in an eighteenth-century text by Seien Kitao, titled *Azuma Kyoka Bunko* (*A Book of Japanese Comical Poems*, fig. 3), which Pearson acquired while in Japan. In fact, a careful examination indicates that virtually the entire image, from the hilt and scabbard of the sword to a second brown and white pattern on the robe, has been transformed in the study. The "demon"—in this instance an unknown Kabuki actor in a *Shibaraku* role—loses much of this reference in the final oil (fig. 4).[13]

Fig. 4. Henry Pearson, *Demon F.S.P. #22*, 1955. Oil on canvas, 26 x 36 inches. Collection of the Louise Wells Cameron Art Museum, gift of Terry and Ed Duffy. The designation "*F.S.P. #22*" is Pearson's shorthand for the twenty-second image in the *Fifty Satirical Poems*, the subtitle of the source illustrated in Figure 3.

By the time Pearson left the Art Students League in 1956, his relationship with his principal instructor, Will Barnet, had developed into an important friendship. Barnet and his wife Elena played a central role within a group of artists and associates, including, among many others, Charmion von Wiegand, James Rosenquist, Ray Donarski, and Betty Parsons, which provided social and professional sustenance throughout the latter half of the 1950s. Barnet in particular was instrumental in the placement of Pearson's work in group shows, and no doubt was at least in part responsible for the younger artist's election as a member of the American Abstract Artists group. To support himself, Pearson first hired on as an assistant in the Contemporaries Gallery, and then beginning in late 1957, he spent three years working for a phonograph company run by Unicorn Publishers, listening for disk imperfections.

His first one-man exhibition, in 1958 at the Workshop Gallery, featured not surprisingly a variety of geometric canvases. At the time, however, Pearson's compositions were progressing toward greater simplification, and within a year his paintings regularly contained a single hard-edged image, often in the shape of an "I" or an "H." With his *Great Black* of 1959, Pearson suspected that he was "on the verge of becoming decadent within the style. This was a disturbing painting in that it fought with itself. The last geometric canvas I destroyed in early 1961. After the purity of *Great Black* everything else seemed somewhat anti-climactic. They had gotten down to such essentials that I would have had to go backward to continue."[14]

Deliverance from the dilemma grew out of an incident that had occurred earlier in 1959. Pearson would occasionally outline his ideas for geometric paintings while on the job listening to recordings. One sketch proved to be especially troublesome:

> Not being successful in the particular one that I was planning, I doodled a bit and out of curiosity wondered to myself how it would be if I were to round the corners. Until this point I was strictly horizontal and vertical. And I rounded the corners and I said to myself, 'now this is too much like a collar button.' However, in keeping with the doodling I drew another line around the curving line that I had just created at varying distances from the first one just as I would do if I were to do a geometric painting. And seeing what happened, quite suddenly I remembered my own background of about . . . how much I enjoyed making topographical drawings, and I proceeded immediately to draw a third line and didn't stop at that but immediately went to a drawing pad and took out some colored crayons I proceeded to make several drawings using this repeated motif, I don't know how else to call it, with varying spaces between the lines just as I had done in topography.[15]

The earliest efforts were contour maps of his own invention (cat. no. 12), with spatial expansions and contractions that imitated the interpretive drawings he had done during the war. Although the movement in these drawings corresponded to the manipulation of space in his rectilinear paintings, Pearson quickly became disenchanted. For an artist dedicated to abstraction, they were too illustra-

tive, too representative of landscape. He discovered, however, that by placing the lines closely parallel to one another, he could avoid the feeling of landscape and produce suitably nonobjective images he could call his own (cat. nos. 13-19 and 22-25). Once certain of eluding any reference, he revisited the linear fluctuation of the very first drawings done a few months earlier—what he characterizes as "breathing"—to create some of the most magnificently dramatic abstractions of the new style (cat. nos. 20 and 21).

For over two years, Pearson developed this novel theme with crow quill pen on paper while continuing to execute rectilinear canvases. By 1961, he had sufficient confidence in the drawings to include a selection in his second one-man show, at the Stephen Radich Gallery, in tandem with the hard-edge paintings. Although both received decent notice,[16] the exhibition signaled the end for Pearson's geometric period. That same year he extended the idea to canvas, and thereafter, for nearly the next fifteen years, his principal direction in painting was linear as well. The adaptation to painting, however, did not assign the drawings to the level of study. In a sense, painting and drawing became comparable in expression, with the distinction being not a question of quality, significance, or level of completion, but merely a matter of materials.[17]

Pearson explored extensive variations on the linear theme with his drawings, often in directions that he would not, or could not, approach on canvas. One of the first permutations involved a finger-like motif—layered, digit-like contours extending throughout part or all of the composition (cat. nos. 13 and 24)—which peaked, at least in black and white, with *Black Sun* of 1965 (cat. no. 31). The "bull's-eye" features concentric rings emanating from a single, usually off-center point (cat. nos. 29 and 50). These evolved into some of Pearson's more successful images, known collectively as the Horizon Series, when individual bull's-eye segments (cat. no. 49) began to appear in opposition to one another to form a dark ridge at the point of conjunction (cat. nos. 30 and 51). Another important variation occurred when he reintroduced a slightly calmer version of the breathing pattern, beginning in 1963, to produce the contoured imagery for which Pearson is perhaps best known (cat. nos. 27-28 and 43-44).

His most innovative application came about in a rather innocuous fashion. Walking down the street one day in early 1963, he noticed a beach ball in the window of a toy store. Before he got to the end of the block he had put the ball and his striated compositions together as he reflected on what it would be like to do an endless drawing. He acquired the ball, covered it in several layers of papier-mâché, and applied a reddish brown pattern over an olive green ground. It was a stunning work; unfortunately, the original beach ball, like other plastic spheres he auditioned, presented a problem once they deflated. They couldn't be discarded without defacing the drawing, so he turned to more resilient supports, from custom-made cherry wood billiard balls for the smaller pieces, to aluminum globes for the largest.[18] *T.E.E.M. Ball* (cat. no. 41)—named for one of Pearson's students, Terry Duffy, and her family (husband Ed and daughters Elisabeth and Margot)—hails from the latter category. Its intricate branching motif, designated "Tree of Life" after a title given to a similarly decorated painting by Betty Parsons,[19] represents yet another design common to this period (see cat. no. 26).

Throughout the first half of the 1960s, Pearson's recognition in New York grew steadily. Annual one-man shows at the Radich Gallery, and regular participation in group shows around the city, including several at the Whitney Museum of American Art and The Museum of Modern Art, helped to establish a level of some prominence in the New York art world. The Whitney and MoMA each added Pearson's work to their collections, and, as the Corcoran Gallery of Art and the Albright-Knox Art Gallery, among others, acquired pieces, he began to receive national attention. In 1964, he was awarded a Ford Foundation grant to attend the Tamarind Lithography Workshop in Los Angeles, where he created a *livre de luxe* of Samuel T. Coleridge's *The Rime of the Ancient Mariner*. The fourteen illustrations served as a compendium of the various images he had embodied in his work—and particularly in his drawings—up to that time.

In the fall of 1964, William Seitz of The Museum of Modern Art visited to solicit Pearson's participation in *The Responsive Eye*, a major exhibition he was organizing for the following year around the Op Art phenomenon. Pearson had mixed feelings about the invitation. Although his art possessed (and predated by several years) an optical vibration similar to the Op artists' intentions, the effects were by-products of an approach far more intuitive. Nonetheless, the opportunity to be represented in an important exhibition travelling to several venues nationally outweighed any philosophical differences he may have had with the group. Seitz selected a large painting from the Horizon Series, *Black on White* (fig. 5), which Pearson had completed just days before the visit. *The Responsive Eye* opened, on February 23, 1965, to a good deal of popular appeal, but considerable negative response on the part of the critics. Still struggling with Pop's assault on the Abstract Expressionist hegemony, writers found little to admire beyond the seductively pulsating surfaces.[20] In a general review of the Op Art trend published just weeks following the opening, Lucy Lippard wrote:

> So far it is an art of little substance with less to it than meets the eye, earmarked
> by a dependence on purely technical knowledge of color and design theory
> which, when combined with a conventional geometric or hard-edge framework,
> results in jazzily respectable jumping surfaces, and nothing more.[21]

The criticism made Pearson feel all the more that he neither deserved nor desired the association. "I have been included willy-nilly in the optical art movement," he declared, "but I don't think I really belong with the group because, actually, my work has a romantic nuance and the work of most members of the group is hard edge."[22] Lippard concurred, and in the same essay in which she attacked the Op artists, she went to some length to distinguish him from other members of the movement:

> While he arrived empirically at effects relating to moirés, his art is romantic and
> even expressionist, rather than coolly and scientifically objective. Despite their
> meticulous character, Pearson's dizzying labyrinths of line are executed freehand,
> in a slightly hesitant and non-mechanical manner. His knowledge of and intu-
> itive sense of color are not limited to the obvious combinations that have already
> become trite on the optical circuit[23]

Fig. 5. Henry Pearson, *Black on White*, 1964. Oil on canvas, 78 x 78 inches. The Museum of Modern Art. Purchase. © 2001 The Museum of Modern Art, New York.

Two months later, Lippard buttressed her defense with a full-length article that, with a carefully constructed argument for subjective content, firmly positioned Pearson's linear abstraction beyond the parameters of mere optical illusion.[24] Further advocacy came from Will Barnet, who in an introduction to one of Pearson's exhibitions, emphasized the poetic inspiration for his work:

> His linear-optical style exchanges geometric forms for the tensions and optical effects created by closely spaced lines; but the personal and poetic source is the same. Just as in his earlier style he was concerned with a subjective expression, so is he in his optical style. His work is not a scientific experiment with optical effects. These effects are only a vehicle.[25]

Despite these efforts, the Op Art association persisted, and for a time became a central factor in determining his inclusion in other group exhibitions.[26] Pearson may have exacerbated the condition by adding bold color to his work starting in 1966, and once again, the drawings demonstrated his most inventive compositions. Some featured subtly shaded fragments (cat. no. 32) or the omnipresent disk (cat. nos. 33-35). For the most part, however, Pearson preferred to extend the design to the paper's edge (cat. nos. 36-40). Especially effective, perhaps because of the slightly larger format that affords sufficient space for the color to reconcile with the linear array, is *Crucible I* of 1967 (cat. no. 40). In 1969, he reprised the finger motif, this time—in keeping with the new harmony—richly variegated (cat. nos. 45-48).

The North Carolina Museum of Art honored Pearson with a retrospective exhibition during the spring of 1969.[27] More than half of the nearly seventy-five works showcased his linear style, which, then ten years in the making, continued to hold his imagination. "When I first began the exploration of what could be done with a line or two," he wrote in the fall of 1969, "I had the very strong feeling that I could spend the remainder of my life on this one theme." But then he added, as a reflection on how he had started out on the linear path, "Nonetheless, I hope that if that right new stimulus comes along I will be able to throw over everything and take the strange unexplored new fork in the road."[28] Line in his work remained strong into the early 1970s, during which time, with muted color (usually reverting to black and one other tone) and a gentler ebb and flow of his signature patterns, he produced perhaps his finest distillation of the style.

Another change in direction, however, rested just ahead, and the catalyst was not new, as he had anticipated, but an old friend. Solid, hard-edged forms began to work their way back into Pearson's work during the mid-1970s. "I had begun to realize," he recalls, "that I had more to say regarding the geometric path I had taken earlier in my career."[29] One incident in particular, occurring circa 1955, influenced the recurrence. Although mainly focused on geometric abstraction in his painting from 1954 through 1961, he frequently, and comfortably, slipped back into a more realistic style reminiscent of the work he had done while studying with Reginald Marsh. On one of these occasions, while waiting for the bluish-white ground he had prepared for the painting to dry, a black rectangular piece of paper floated from an unstable perch onto the wet canvas. "I loved the starkness

of the black rectangle against all that space. At the time, it was something I didn't—couldn't really—develop. But it stayed in my psyche as a potential idea."[30] The new geometry resurfaced first in sketches containing single triangles, squares, and rectangles (cat. nos. 52 and 53) that evolved into hauntingly solemn, nearly monochromatic statements when fully fleshed out on paper (cat no. 54).[31] A visit to The Metropolitan Museum of Art's Lehman Collection gave rise to the next manifestation: black rectangles of varying dimensions superimposed upon postcard reproductions of well-known historical paintings.[32] Finally, in a gesture closest to the original happenstance nearly twenty-five years earlier, in 1979 Pearson transferred the dark emblem to his own quite realistic paintings and colored drawings (cat. nos. 55-58 and fig. 6).

With the turn of the decade Pearson brought geometric abstraction back in full force, richly restated in the form of narrow, totemic-like compositions and randomly colored checkerboards. Drawing reverted to the role of preparatory study for hard-edged paintings, and the line that had decorated nearly all of Pearson's work since the early 1960s, save for the occasional anachronic reprise (cat. no. 51), found its sole sanctuary in illustrations for the poetry of Seamus Heaney. Pearson's introduction to the work of Heaney, in 1975, resulted in an immediate admiration that readily became mutual after the two met a few years later. In 1981, he published the poet's "Sweeney Praises the Trees," and included opposite the title page an image that fused some of his linear inventions with ancient Celtic designs (fig. 7). The following year he selected a large number of Heaney's verses and published them, together with eight more similarly derived illustrations, under the title *Poems and a Memoir*.[33] It is perhaps fitting that Pearson's lines found repose beside the words of a poet, particularly one of Heaney's caliber. For there is something about Henry Pearson's line—best voiced in the drawings which first and most intimately gave it breath—that, like our finest bards, transcends the ordinary and transports us to regions first glimpsed or felt only by the few.

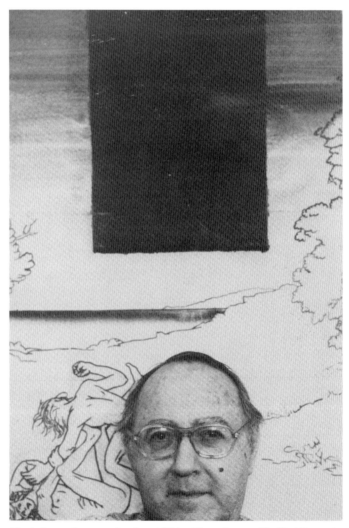

Fig. 6. Postcard announcing the exhibition *Henry Pearson: The Black Rectangle* at Marilyn Pearl Gallery, February 5 - March 1, 1980. Pearson appears before a drawing for the unrealized painting *Cain and Abel*. Photograph by Marvin Lazarus.

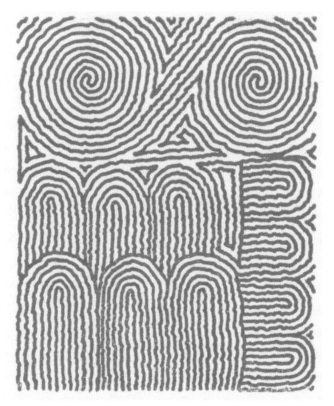

Fig. 7. Henry Pearson, illustration for Seamus Heaney's "Sweeney Praises the Trees," 1981. Offset lithograph, 3 7/8 x 3 3/16 inches.

Endnotes:

[1] Jean-Auguste-Dominique Ingres to Edgar Degas, quoted in John Rewald, *The History of Impressionism*, 4th edition (New York: The Museum of Modern Art, 1975), p. 16.

[2] Letter to Louis and Estelle Pearson, December 15, 1959, in *Henry Pearson Papers*, Washington, D.C.: Archives of American Art, 1967, reel 95. Quoted in Nina Parris, "Henry Pearson," exhibition brochure, (Columbia: Columbia Museum of Art, 1988), [p. 2].

[3] From an interview with William Wright, taped in 1950 for a radio program aired in 1951. Quoted in Francis O'Connor and Eugene Thaw, editors, *Jackson Pollock: A Catalogue Raisonné of Paintings, Drawings, and Other Works* (New Haven: Yale University Press, 1978), vol. 4, p. 251.

[4] *Sumi-e* is executed with a brush and a black color similar to ink on paper or, as in Pearson's case, silk. Pearson in actuality never received the framed *sumi-e* back from the gallery. Returning to pick it up, he was told, "We hope you don't mind, we couldn't resist. An American nurse came in, and fell in love with it, thinking it was a fine example of Japanese painting. She wanted terribly to buy it, so we sold it to her!"

"So somewhere in the United States," Pearson muses, "there may be floating around one of the earliest Pearson originals, though no one would know it to look at it!" (Reported during a telephone conversation with the author, June 6, 2001.)

[5] Ibid.

[6] The United States Air Force was separated from the Army and established as an independent arm of the military in 1947.

[7] Henry Pearson, "Dissertation on Whether I Have a Philosophy of Painting or Even on Art in General," unpublished manuscript, written at the request of Charles Springman for the North Carolina Arts Council's newsletter, October 14, 1969, [p. 1].

[8] Pearson's opinions about Marsh as a teacher changed slightly over the years. In a 1965 conversation with Lucy Lippard, he claimed, "Marsh was not a good teacher, but his principles were good. He gave you a physical idea of what to do and left it to you to see what happened when you did it." (Recorded in Lucy R. Lippard, "Henry Pearson, *Art International*, May 1965, p. 29.) Several years later, in the Arts Council article listed above (note 7), his tone had softened a bit, saying then of Marsh, "He certainly could and did teach how [to paint]," and that despite his aversion to abstraction, "He knew something that I was not to discover until much later: that the elements that can make a good abstraction apply equally to a representational painting." (Henry Pearson, "Dissertation," [pp. 1-2].)

[9] Robert Ward Johnson died in 1953 not long after Pearson began his studies, and so Pearson moved on to Robert Beverly Hale for his drawing instruction. While teaching at the Art Students League, Hale, whom Pearson categorizes as a brilliant teacher, was also curator of American Art at The Metropolitan Museum of Art, from 1948 to 1966.

[10] Pearson is fond of relating the moment when he brought a canvas to Marsh—a Renaissance-style portrait—that he had just completed in Barnet's class. Pearson asked, "Care to see what I've been doing in Will Barnet's class?" Marsh, standing in the doorway, replied with dismay, "I've been wondering where you've been." But when he looked at it, he pointed out the same strengths and weaknesses, for the same reasons, as Barnet had. (Telephone conversation with the author, June 15, 2001.)

In another story that demonstrates Marsh's formal consistency, Pearson tells of a fellow student who, while working on an abstraction, was asked by Marsh why he was wasting his time. The student responded, with a bit of animosity (and some courage) over having been reproached by someone he considered to be somewhat out of touch with contemporary issues, that he doubted Marsh would be able to accomplish such a painting. Marsh shrugged his shoulders, but returned the next day with a freshly painted non-objective canvas. "The surprising and embarrassing thing about it," reported the student, "was that it was damned good!" Henry Pearson, "Dissertation," [p. 2].

[11] The Rockefeller Guest House, designed by Philip Johnson for Blanchette Rockefeller, wife of John D. Rockefeller III, was built at 242 East 52nd Street in 1949-50. The town house first opened to the public in November of 1954 with the exhibition visited by Pearson, which featured work owned by The Museum of Modern Art's Junior Council members. See Victoria Rodriguez-Thiessen, "The History of the Rockefeller Guest House," under Lot 268, "The 'Rockefeller Guest House,'" (n.p.) in *Masterworks: 1900-2000*, auction catalogue (New York: Christie's, June 8, 2000).

Accompanying a mention of the exhibition, cited by Rodriguez-Thiessen, in *Harper's Bazaar* ("Young Collectors' New York Housewarming," November 1954, pp. 160-61; 193), is a photograph recording the hanging of an unidentified Suprematist painting by Malevich.

[12] In a conversation with Jane Hall, reported in her column "Hall Marks" in *The News and Observer* (Raleigh, NC, May 10, 1959), Pearson states that his painting had evolved to a point where it was not based on any recognizable form. He is then quoted: "To me . . . this was a most startling and refreshing realization and this led directly to the use of abstract thought as a basis for starting a painting—as in music, the sound is the music. In my thoughts, the painting is the thought."

[13] The "*F.S.P. #22*" in the title refers to the twenty-second image in Kitao's book, here designated as *Fifty Satirical Poems.* Pearson has recently allowed that nearly all of his earlier geometric abstractions, those created through 1958, began with some kernel selected from his visual experience. (Telephone conversation with the author, June 1, 2001.)

[14] Quoted in Lucy R. Lippard, "Henry Pearson," p. 30.

[15] Dorothy Seckler, "Tape-recorded Interview with Henry Pearson," Archives of American Art, March 9, 1965, typescript p. 3.

[16] Sydney Tillim, writing for *Arts Magazine* (February 1961, p. 55) found the drawings "much more satisfying." Lawrence Campbell's review in *ArtNews* (February 1961, p. 12) was more neutral, although he noted a "romantic quality" in the paintings that was "even more marked in the drawings."

[17] "Having done as many drawings as I did, it occurred to me that sooner or later I was going to be wanting to try this method in oil. So, of course, I did, and I turned out two fair-sized, shall I say, painted drawings? I don't know how else to call them. I did at first call them linear paintings and I guess I still call them linear paintings when you come right down to it. They were simply black oil on white oil and they were done with a fine-bristle brush and I was trying to make them as fine lined as I was making the drawings." Seckler, p. 7.

[18] Actually, Pearson's largest support in this vein was a weather balloon, nearly five feet in diameter, which he inflated and decorated in the garden behind the Martha Jackson Gallery for the *Vibrations 11* exhibition (December 29, 1964-January 30, 1965). A narrow doorway precluded its installation in the gallery, so the huge sphere remained in the garden for the opening, where it amazed visitors. Unfortunately, a wind later that evening caused the ball to roll against something jagged in the garden, and it was discovered irretrievably deflated the next morning.

[19] Pearson applied a title only when a work suggested a name upon completion, and he very rarely made up a title simply because he, or someone else, felt it needed one. Such was the case when, in 1963, Betty Parsons, a friend and advisor for quite some time and still years away from becoming Pearson's dealer, wanted to purchase a painting and queried Pearson regarding its title. "What's the name of the work?" she asked.
"It doesn't have one," replied Pearson.
"I like names."
"Well, then you name it."
And so she did. Because it featured a valley image spreading like vines or branches on a tree, she titled it *Tree of Life.* (Telephone conversation with the author, April 5, 2001.)

[20] See Irving Sandler's account of the Op Art movement in *American Art of the 1960s* (New York: Harper & Row, 1988), pp. 222-230.

[21] Lucy R. Lippard, "New York Letter," *Art International*, March 1965, p. 50. Quoted by Sandler, p. 226.

[22] Jane Hall, "Hall Marks," *The News and Observer*, Raleigh, N.C., September 5, 1965. Quoted in Nina Parris, "Henry Pearson," [p. 1].

[23] Lippard, "New York Letter," p. 50.

[24] Lippard, "Henry Pearson," pp. 29-33. Lippard's *Art International* article remains the finest critical examination of Pearson's work from the 1950s and early 1960s.

[25] Will Barnet, "Introduction" in *Henry C. Pearson*, exhibition catalogue, Tweed Gallery, 1965, [p. 1].

[26] For example, the 1965 exhibition *Op Art, una extension de la vista . . .* at El Centro Venezolano Americano, and *Art with Optical Reaction* held at the Des Moines Art Center, January 21-February 20, 1966.

[27] *Henry Pearson: A Retrospective Exhibition*, April 27-June 1, 1969.

[28] Pearson, "Dissertation," p. 3.

[29] Telephone conversation with the author, March 30, 2001.

[30] Ibid.

[31] Lucy Lippard, when reviewing an exhibition of these latter works on paper at the Betty Parsons Gallery in early 1976, couldn't avoid associating them (and, I think, accurately) with the black monumental slab in Stanley Kubrick's *2001: A Space Odyssey* ("Henry Pearson: Black Icons into an Outer Space," *Art-Rite*, 11-12 (Winter/Spring), 1975/76, n.p.

[32] A group of these were exhibited at the Truman Gallery, October 11-November 5, 1977. That year he issued similar imagery in a portfolio of eight serigraphs on postcards, titled *Henry Pearson, 1977*. In an introduction accompanying the portfolio, long-time friend and colleague James Rosenquist described their meditative effect.

[33] The relationship between Seamus Heaney and Henry Pearson, including the details surrounding these publications, is one of the principal subjects of an article by Thomas E. Douglass titled "'Time and the Smell of the Earth.' Seamus Heaney Returns to the Land of Henry Pearson," in *North Carolina Literary Review*, Number 5, 1996, pp. 27-44. Henry Pearson's admiration for Seamus Heaney has been expressed in the creation of one of the most comprehensive collections of Heaney's writings in the United States. Much of this collection has been donated by Pearson to the Wilson Library at the University of North Carolina, Chapel Hill.

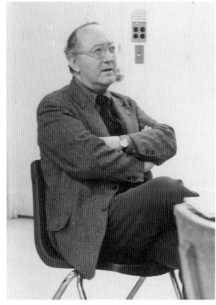

Henry Pearson in 1977 at the New School for Social Research, where he taught for thirty years.

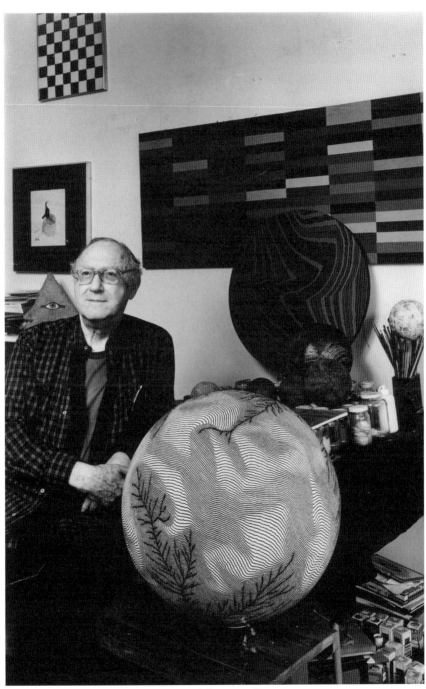

Henry Pearson in his studio, 1987. Photograph by Peter Bellamy.

Illustrations

Catalogue numbers 1, 4-6, 9-11, 24, 32-40, 45-48, 50, and 52-58 can be found on pages 33-48.

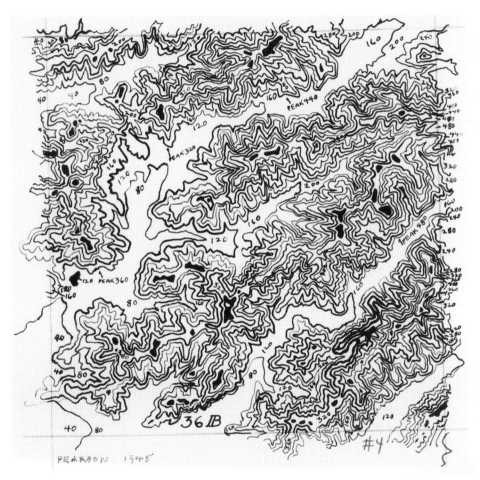

2. Drawing after Imperial Japanese survey map, 1945. Ink, crayon, and graphite on tracing paper, ca. 6 x 6 inches (image), 10 x 8 inches (paper).

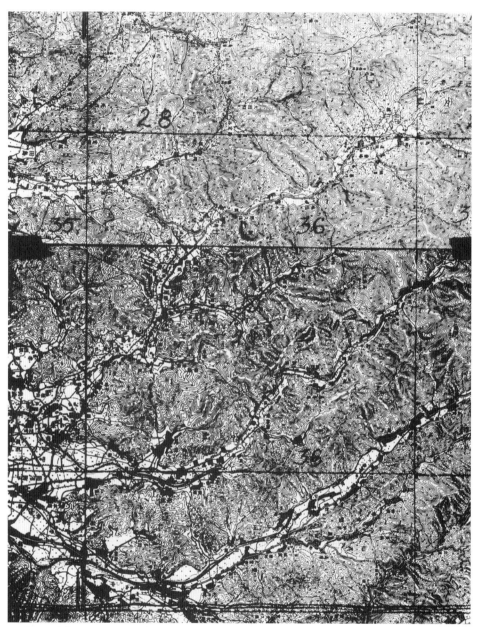

3. Imperial Japanese survey map, ca. 1936. Photograph, 10 x 8 inches.

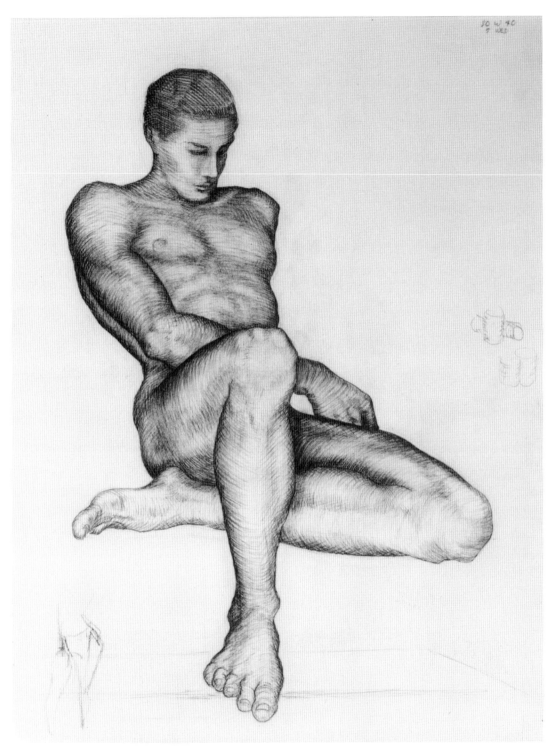

7. Male figure study, 1953. Black chalk on paper, 23 7/8 x 18 1/4 inches.

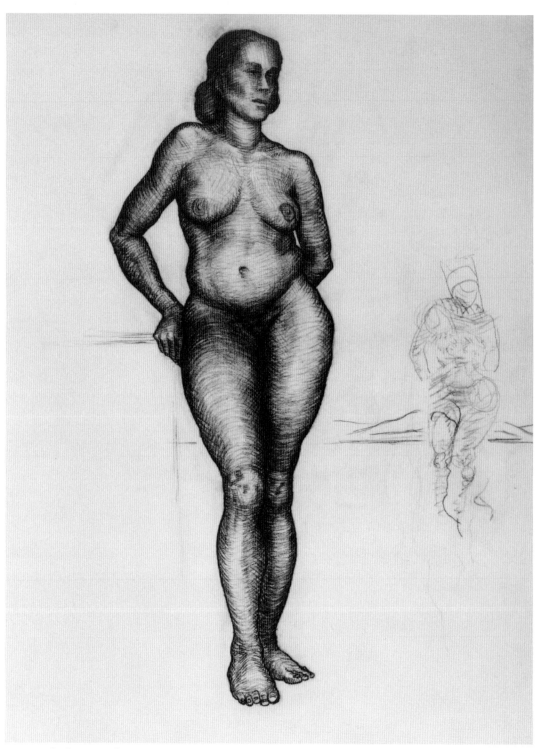

8. Female figure study, 1953. Black chalk on paper, 23 3/4 x 19 5/8 inches.

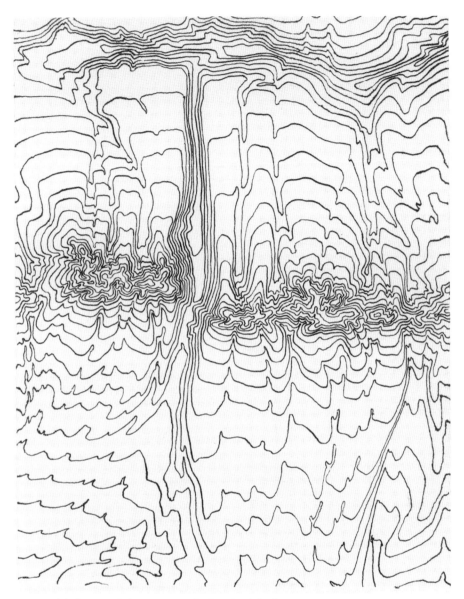

12. Untitled, 1959. Ink on paper, 6 1/4 x 4 7/8 inches.

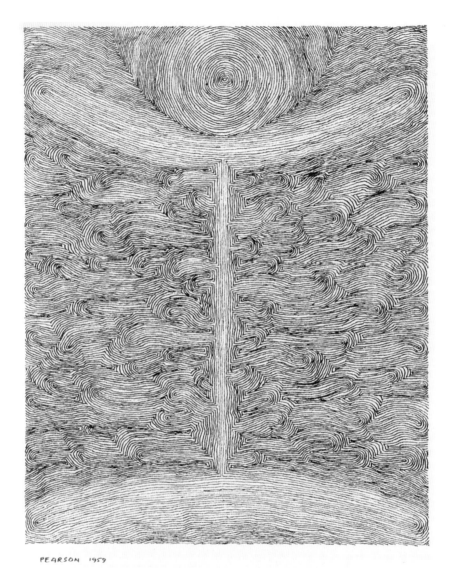

13. Untitled, 1959. Ink on paper, 5 13/16 x 4 5/8 inches (image), 8 5/8 x 6 inches (paper).

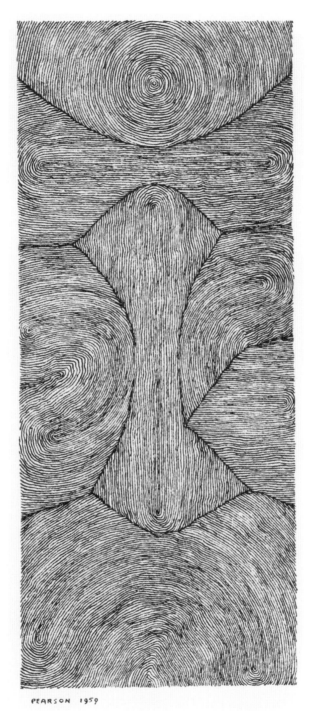

PEARSON 1959

14. Untitled, 1959. Ink on paper, 6 1/2 x 2 3/4 inches (image), 8 5/8 x 6 inches (paper).

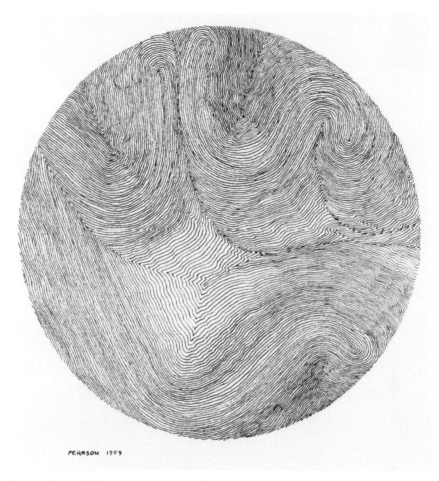

15. Untitled, 1959. Ink on paper, 4 7/8 inches diameter (image), 8 5/8 x 5 15/16 inches (paper).

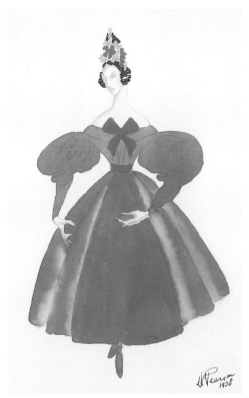

1. Costume design for the ballet *Le diable boiteux*, 1938. Graphite and gouache on paper, 10 x 7 inches.

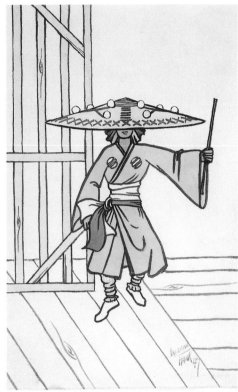

4. *Ininawa*, 1947. Ink and watercolor on paper, 8 15/16 x 5 15/16 inches.

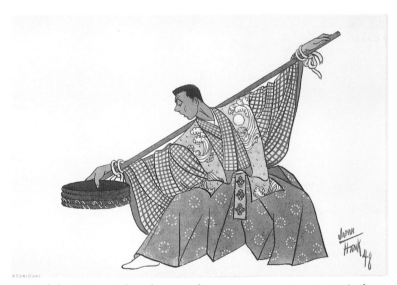

5. *Beshibari*, 1948. Ink and watercolor on paper, 6 1/16 x 8 15/16 inches.

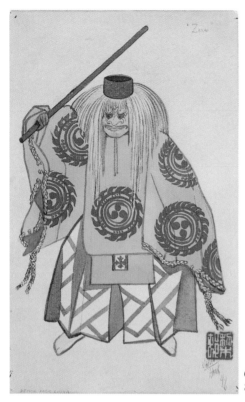

6. *Zekai*, 1948. Ink and watercolor on paper, 8 15/16 x 5 5/8 inches.

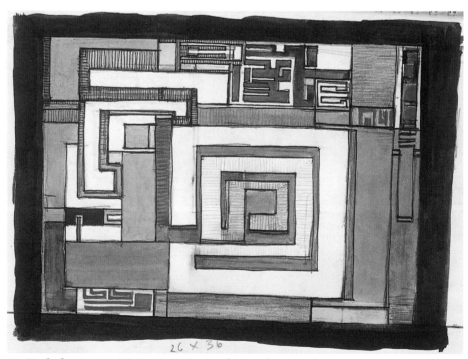

9. Study for *Demon F.S.P. #22*, 1955. Graphite and watercolor on paper, ca. 5 3/4 x 8 inches (image.)

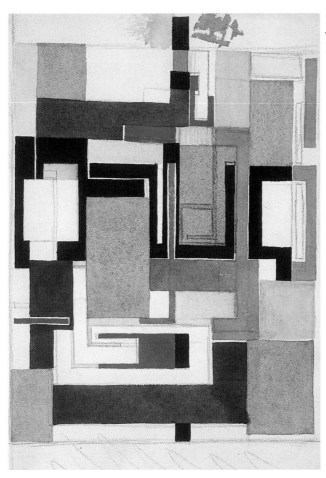

10. Untitled study, ca. 1956-58. Graphite and watercolor on paper, 12 1/8 x 8 7/8 inches (image), 13 7/8 x 9 15/16 inches (paper).

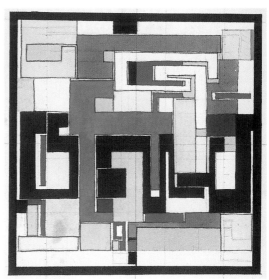

11. Study for *Prolegomenon*, ca. 1956-58. Graphite and watercolor on paper, 8 9/16 x 8 9/16 inches (image), 13 7/8 x 9 15/16 inches (paper).

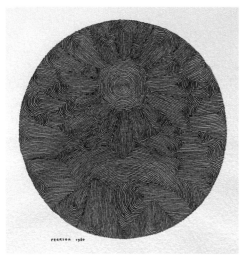

24. Untitled, 1960. Ink and watercolor on paper, 4 inches diameter (image), 8 1/8 x 5 15/16 inches (paper).

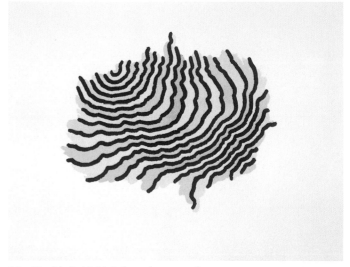

32. Untitled, 1966. Ink and watercolor on paper, ca. 5 3/4 x 7 inches (image), 9 1/16 x 12 3/16 inches (paper).

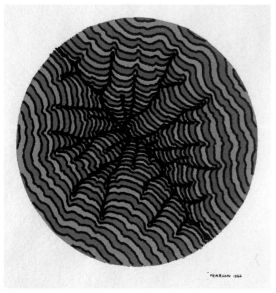

33. Untitled, 1966. Ink and watercolor on paper, 4 3/8 inches diameter (image), 6 7/16 x 6 3/16 inches (paper).

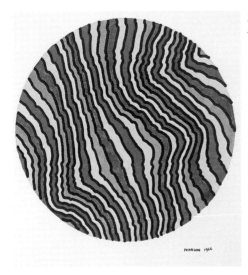

34. Untitled, 1966. Ink and watercolor on paper, 4 7/16 inches diameter (image), 7 11/16 x 7 1/2 inches (paper).

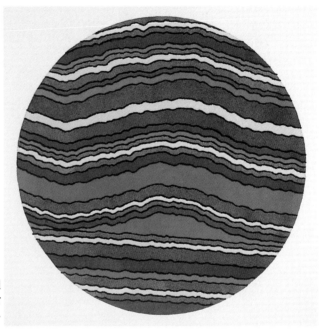

35. Untitled, ca. 1966. Ink, graphite, and watercolor on paper, 7 1/4 inches diameter (image), 9 x 12 3/16 inches (paper).

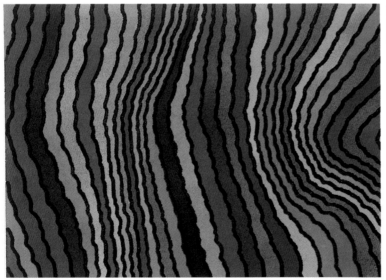

36. Untitled, 1966. Ink and watercolor on paper, 9 x 12 3/16 inches.

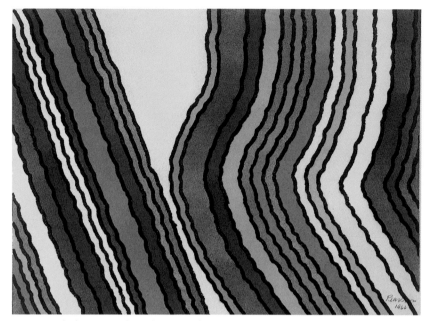

37. Untitled, 1966. Ink and watercolor on paper, 9 x 12 3/16 inches.

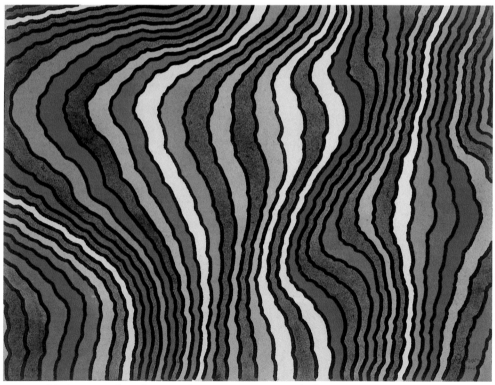

38. Untitled, 1966. Ink and watercolor on paper, 12 x 16 inches.

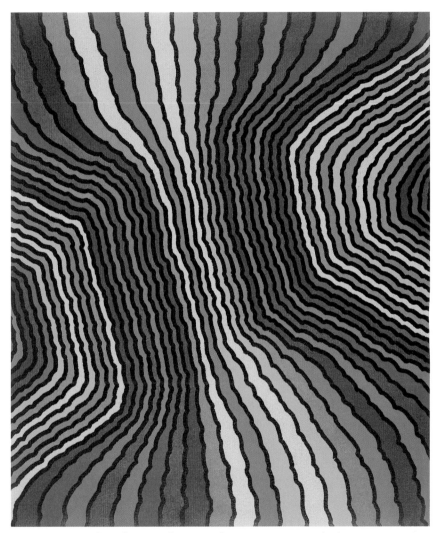

39. *#4 1967*. Ink and watercolor on paper, 12 1/16 x 10 1/8 inches.

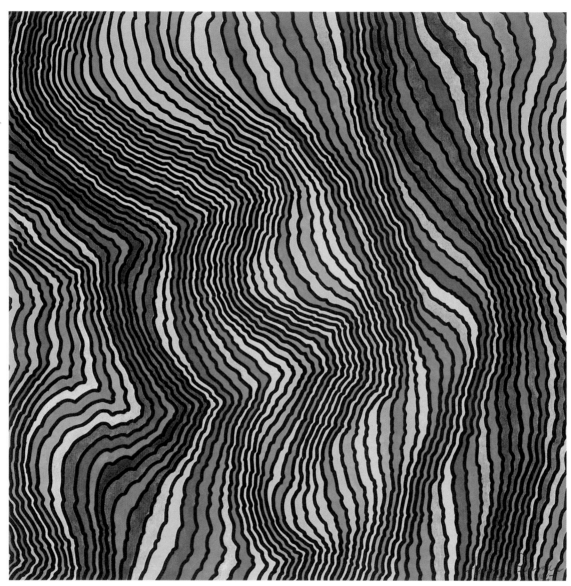

40. *Crucible I*, 1967. Ink and watercolor on paper, 15 x 15 inches.

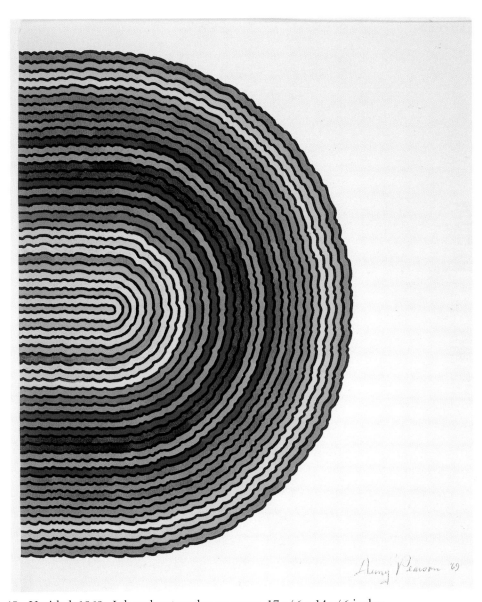

45. Untitled, 1969. Ink and watercolor on paper, 17 1/16 x 14 1/16 inches.

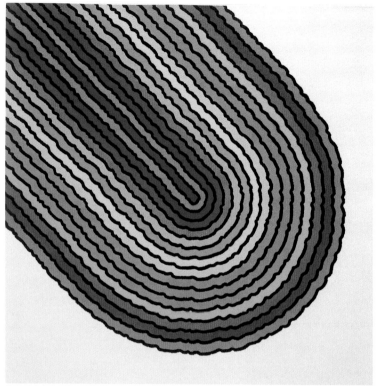

46. *Sagittarius XI (Kamo Ascension I)*, 1969. Ink and water-color on paper, 9 1/16 x 9 1/16 inches.

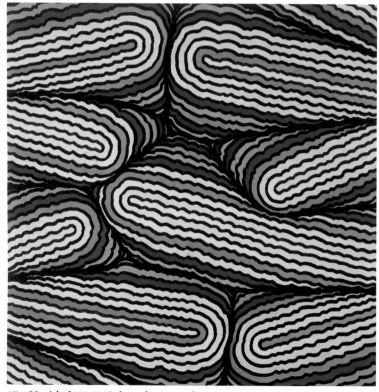

47. Untitled, 1969. Ink and watercolor on paper, 9 x 9 inches.

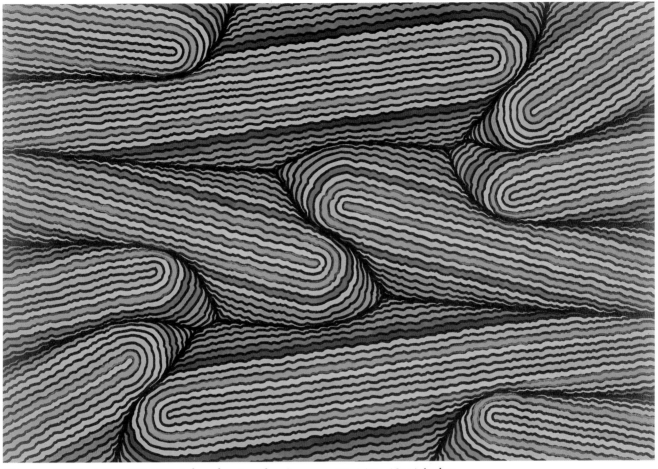

48. *Angular Deviation #15*, 1969. Ink and watercolor on paper, 13 13/16 x 19 7/8 inches.

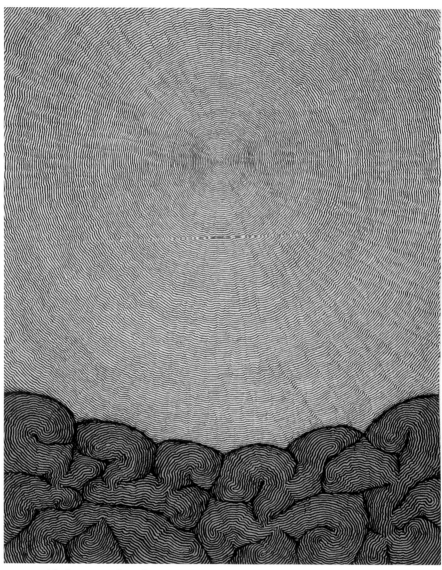

50. Untitled, 1975. Ink and watercolor on paper, 10 x 8 1/16 inches.

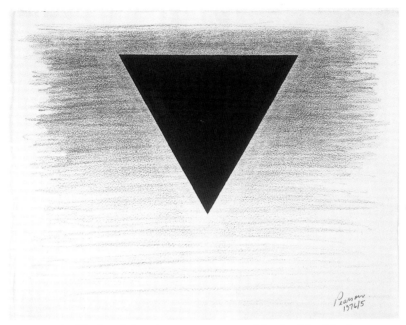

52. *1976/5*. Vinyl and Conté crayon on paper, 13 7/8 x 17 1/8 inches.

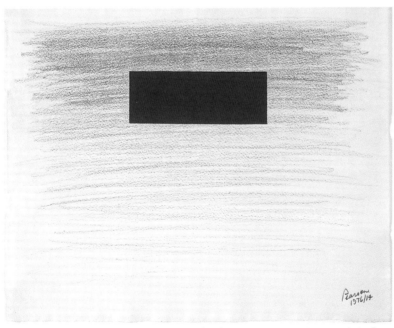

53. *1976/14*. Vinyl, Conté crayon, and ink on paper, 13 7/8 x 17 1/8 inches.

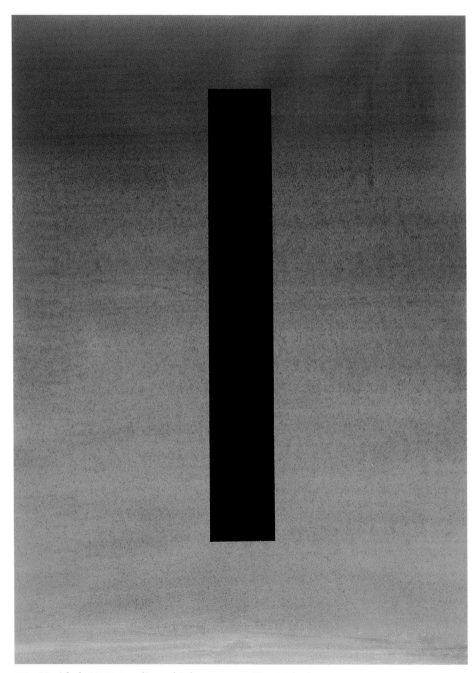

54. Untitled, 1976. Acrylic and ink on paper, 23 x 17 inches.

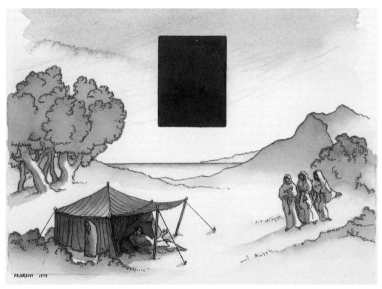

55. *Genesis 18:2*, 1979. Ink and watercolor on paper, ca. 4 13/16 x 6 1/2 inches (image), 5 15/16 x 8 15/16 inches (paper).

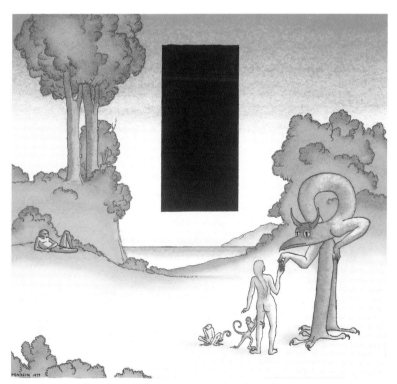

56. *Genesis III:1-6*, 1979. Ink, watercolor, and vinyl on paper, 7 7/16 x 7 7/8 inches (image), 8 15/16 x 9 7/16 inches (paper).

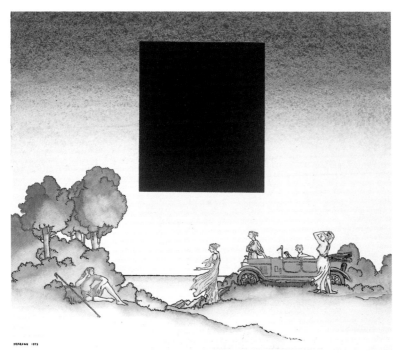

57. *Judgement of Paris with 1924 Lagonda*, 1979. Ink, watercolor, and vinyl on paper, 7 1/2 x 8 5/8 inches (image), 8 15/16 x 10 inches (paper).

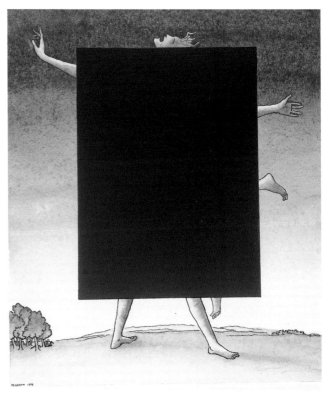

58. *Hercules and Antaeus*, 1979. Ink, watercolor, and vinyl on paper, 7 3/8 x 6 3/8 inches (image), 8 15/16 x 8 inches (paper).

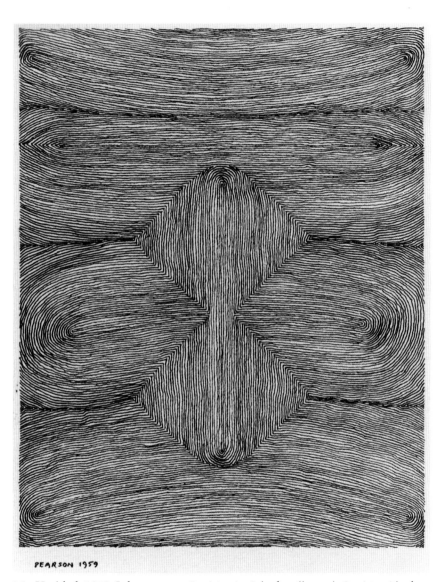

PEARSON 1959

16. Untitled, 1959. Ink on paper, 5 7/16 x 4 3/8 inches (image), 8 9/16 x 6 inches (paper).

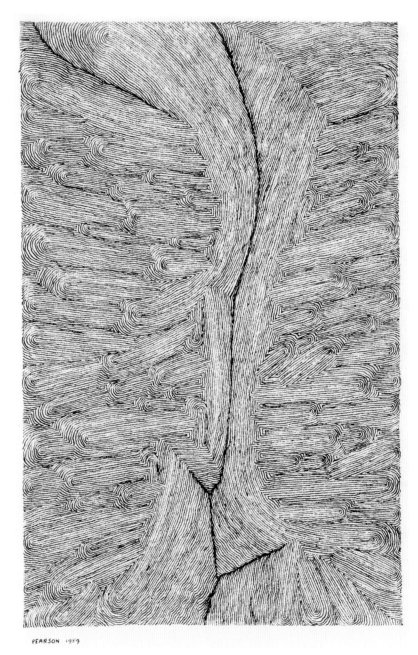

17. Untitled, 1959. Ink on paper, 6 3/4 x 4 3/8 inches (image), 8 3/4 x 6 inches (paper).

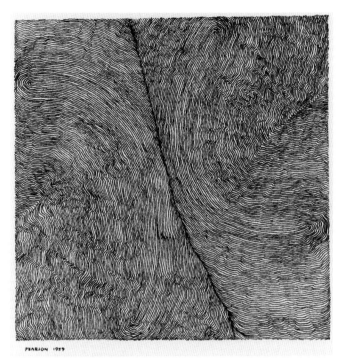

18. Untitled, 1959. Ink on paper, 4 3/8 x 4 3/8 inches (image)
8 7/16 x 6 inches (paper).

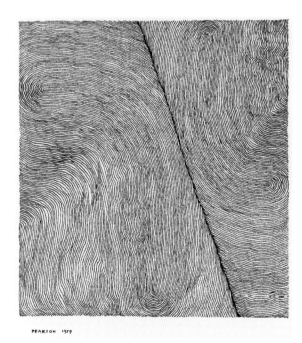

19. Untitled, 1959. Ink on paper, 4 1/4 x 4 inches
(image), 8 11/16 x 6 inches (paper).

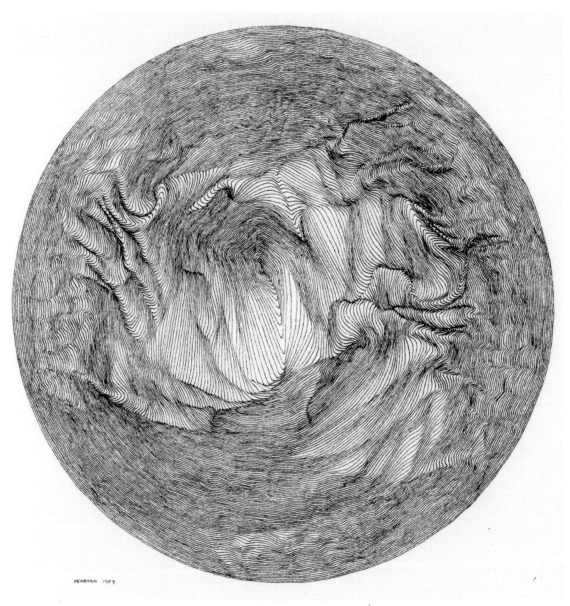

20. Untitled, 1959. Ink on paper, 7 7/8 inches diameter (image,) 11 11/16 x 9 inches (paper).

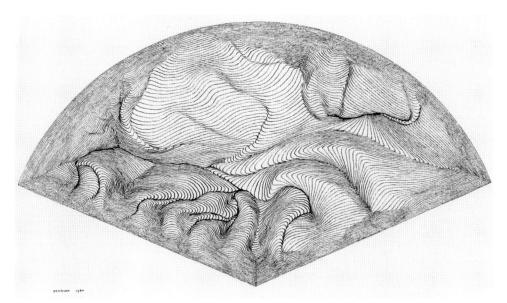

21. Untitled, 1960. Ink on paper, 6 x 11 inches (image), 10 x 13 3/8 inches (paper).

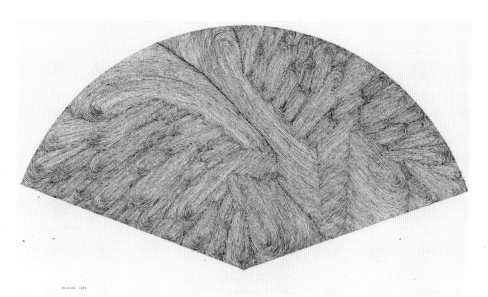

22. Untitled, 1960. Ink on paper, 6 x 11 1/4 inches (image), 10 x 13 5/8 inches (paper).

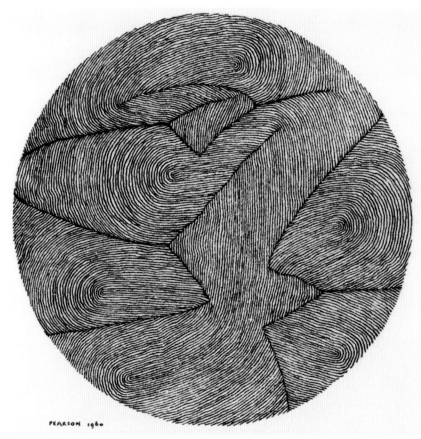

23. Untitled, 1960. Ink on paper, 4 3/8 inches diameter (image), 7 3/16 x 5 3/8 inches (paper).

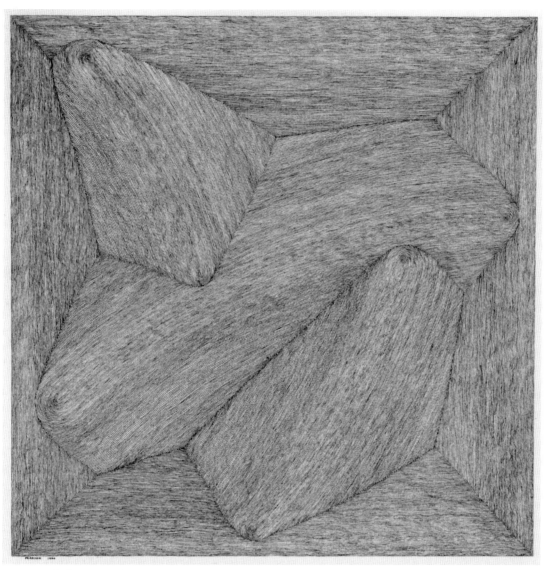

25. Untitled, 1960. Ink on paper, 14 13⁄16 x 14 13⁄16 inches (image), 19 7⁄8 x 19 7⁄8 inches (paper).

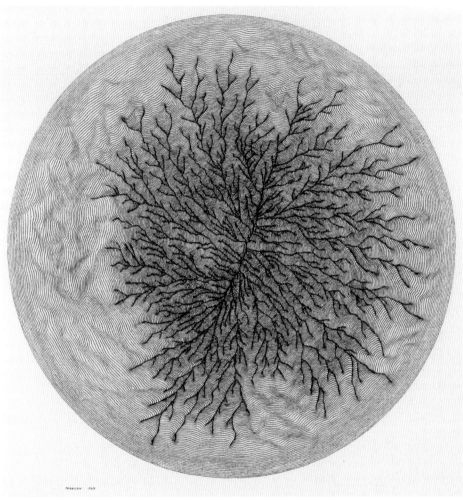

26. Untitled, 1962. Ink on paper, 11 1/2 inches diameter (image), 15 5/8 x 19 7/8 inches (paper).

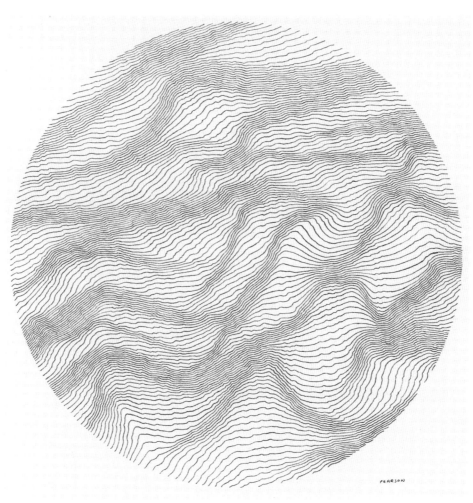

27. Untitled, ca. 1963. Ink and graphite on paper, 8 inches diameter (image), 13 15/16 x 9 15/16 inches (paper).

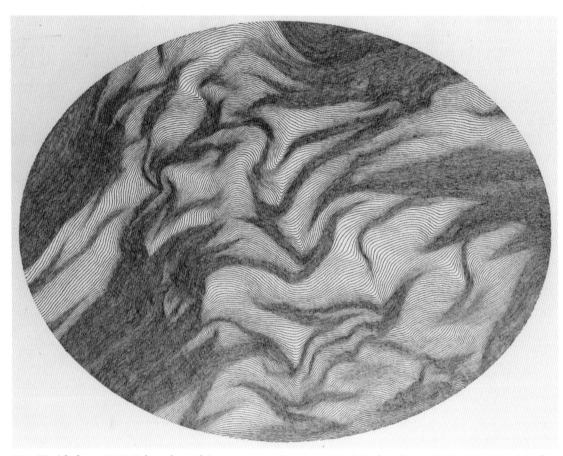

28. Untitled, ca. 1963. Ink and graphite on paper, 11 13 ⁄16 x 15 3 ⁄8 inches (image), 15 3 ⁄8 x 19 7 ⁄8 inches (paper).

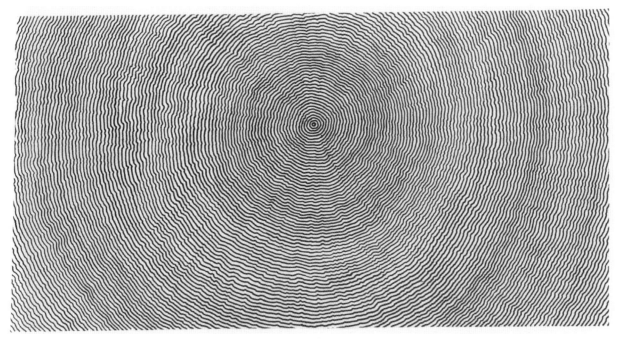

29. Untitled, 1964. Ink on paper, 9 1/4 x 18 inches.

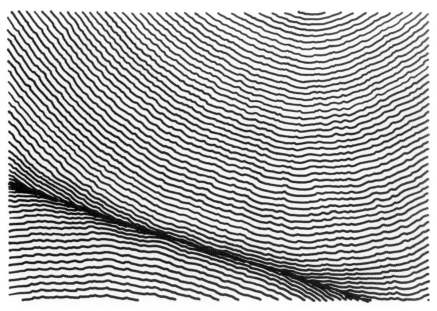

30. Untitled, ca. 1964. Ink and graphite on paper, 6 1/8 x 9 3/16 inches (image),
8 1/16 x 12 1/8 inches (paper).

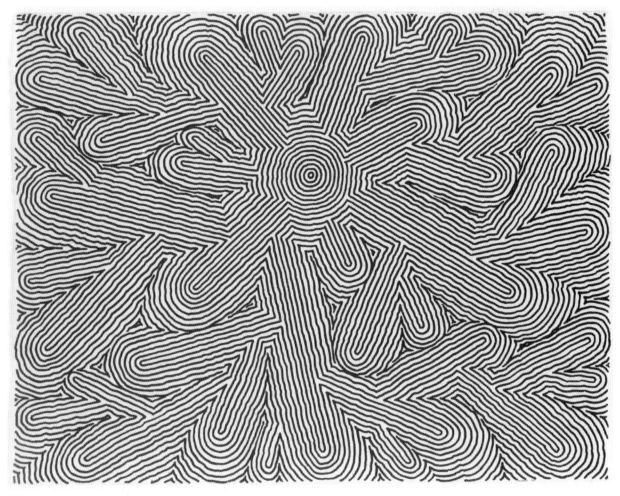

31. *Black Sun*, 1965. Ink on paper, 15 5/8 x 20 1/4 inches.

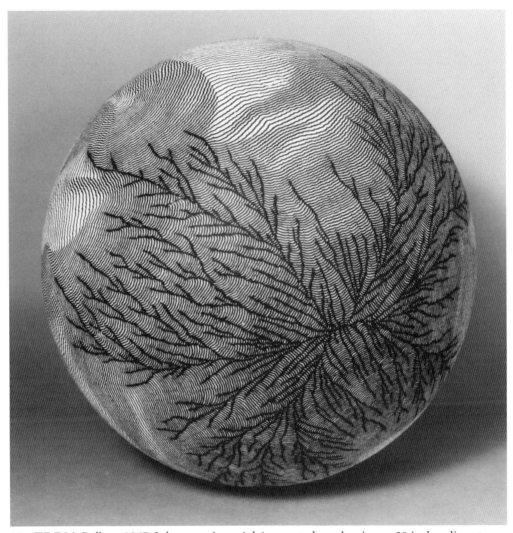

41. *T.E.E.M. Ball,* ca. 1967. Ink on papier-mâché mounted on aluminum, 20 inches diameter.

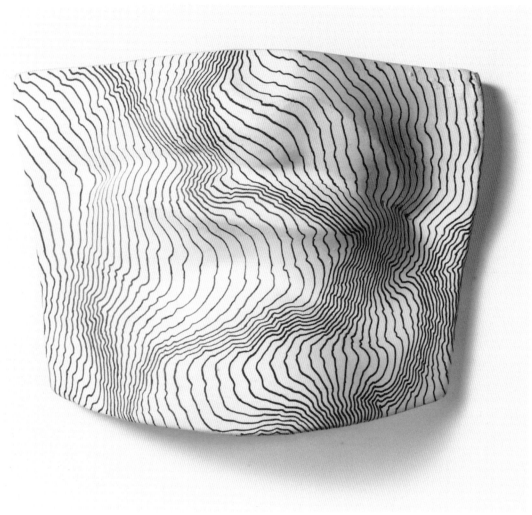

42. *Masque of David II*, 1968. Ink on cast plaster, ca. 4 7/8 x 6 1/2 x 2 1/2 inches.

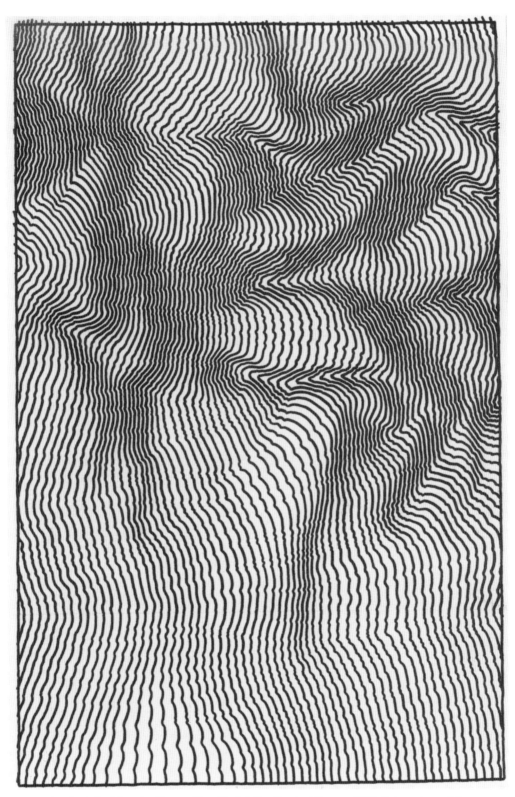

43. Study No. I for Lincoln Center New York Film Festival Poster, 1968. Ink and graphite on paper, 22 7/8 x 15 inches (image), 23 7/8 x 16 1/4 inches (paper).

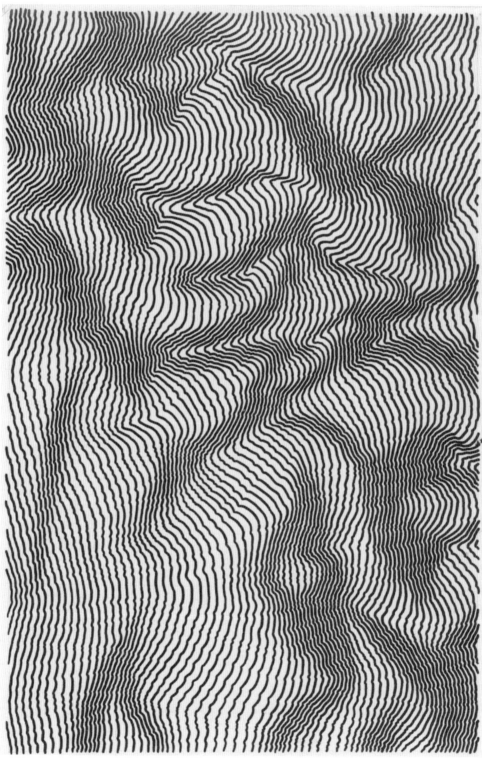

44. Study No. II for Lincoln Center New York Film Festival Poster, 1968. Ink and graphite on paper, 22 7 /8 x 15 1/8 inches (image), 23 1 /16 x 15 7 /16 inches (paper).

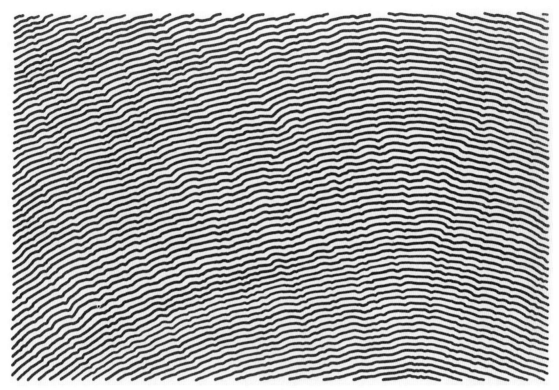

49. Untitled, ca. 1974. Ink and graphite on paper, 6 1/16 x 9 1/8 inches (image), 8 1/16 x 11 3/4 inches (paper).

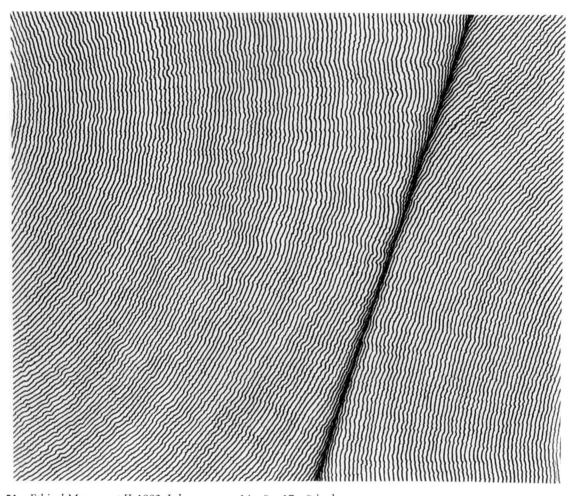

51. *Ethical Movement II*, 1982. Ink on paper, 14 1/8 x 17 1/8 inches.

The Poetry of Line
Drawings by Henry Pearson

Checklist

1. Costume design for the ballet *Le diable boiteux*, 1938
Graphite and gouache on paper
10 x 7 inches
Signed in lower right: H. Pearson 1938
Promised gift of Terry and Ed Duffy
(Page 33)

2. Drawing after Imperial Japanese survey map, 1945
Ink, crayon, and graphite on tracing paper
ca. 6 x 6 inches (image)
10 x 8 inches (paper)
Signed in lower left: PEARSON 1945
Promised gift of Terry and Ed Duffy
(Page 25)

3. Imperial Japanese survey map, ca. 1936
Photograph
10 x 8 inches
Promised gift of Terry and Ed Duffy
(Page 26)

4. *Ininawa*, 1947
Ink and watercolor on paper
8 15/16 x 5 15/16 inches
Signed in lower right: OKINAWA/HANK/47
Promised gift of Elisabeth Duffy
(Page 33)

5. *Beshibari*, 1948
Ink and watercolor on paper
6 1/16 x 8 15/16 inches
Signed in lower right: JAPAN/HANK/47
Collection of Margot Duffy
(Page 33)

6. *Zekai*, 1948
Ink and watercolor on paper
8 15/16 x 5 5/8 inches
Signed in lower right: JAPAN/HANK/48
Promised gift of Terry and Ed Duffy
(Page 34)

7. Male figure study, 1953
Black chalk on paper
23 7/8 x 18 1/4 inches
Promised gift of the artist
(Page 27)

8. Female figure study, 1953
Black chalk on paper
23 3/4 x 19 5/8 inches
Promised gift of the artist
(Page 28)

9. Study for *Demon F.S.P. #22*, 1955
Graphite and watercolor on paper
ca. 5 3/4 x 8 inches (image)
8 x 10 inches (paper)
Promised gift of the artist
(Page 34)

10. Untitled study, ca. 1956-58
Graphite and watercolor on paper
12 1/8 x 8 7/8 inches (image)
13 7/8 x 9 15/16 inches (paper)
Collection of George Wingate
(Page 35)

11. Study for *Prolegomenon*, ca. 1956-58
Graphite and watercolor on paper
8 9/16 x 8 9/16 inches (image)
13 7/8 x 9 15/16 inches (paper)
Collection of George Wingate
(Page 35)

12. Untitled, 1959
Ink on paper
6 1/4 x 4 7/8 inches
Promised gift of Terry and Ed Duffy
(Page 29)

13. Untitled, 1959
Ink on paper
5 13/16 x 4 5/8 inches (image)
8 5/8 x 6 inches (paper)
Signed in lower left: PEARSON 1959
Promised gift of the artist
(Page 30)

14. Untitled, 1959
 Ink on paper
 6 1/2 x 2 3/4 inches (image)
 8 5/8 x 6 inches (paper)
 Signed in ink in lower left: PEARSON 1959
 Promised gift of the artist
 (Page 31)

15. Untitled, 1959
 Ink on paper
 4 7/8 inches diameter (image)
 8 5/8 x 5 15/16 inches (paper)
 Signed in lower left: PEARSON 1959
 Promised gift of the artist
 (Page 32)

16. Untitled, 1959
 Ink on paper
 5 7/16 x 4 3/8 inches (image)
 8 9/16 x 6 inches (paper)
 Signed in lower left: PEARSON 1959
 Promised gift of the artist
 (Page 49)

17. Untitled, 1959
 Ink on paper
 6 3/4 x 4 3/8 inches (image)
 8 3/4 x 6 inches (paper)
 Signed in lower left: PEARSON 1959
 Promised gift of the artist
 (Page 50)

18. Untitled, 1959
 Ink on paper
 4 3/8 x 4 3/8 inches (image)
 8 7/16 x 6 inches (paper)
 Promised gift of Terry and Ed Duffy
 (Page 51)

19. Untitled, 1959
 Ink on paper
 4 1/4 x 4 inches (image)
 8 11/16 x 6 inches (paper)
 Promised gift of Terry and Ed Duffy
 (Page 51)

20. Untitled, 1959
 Ink on paper
 7 7/8 inches diameter (image)
 11 11/16 x 9 inches (paper)
 Signed in lower left: PEARSON 1959
 Promised gift of Terry and Ed Duffy
 (Page 52)

21. Untitled, 1960
 Ink on paper
 6 x 11 inches (image)
 10 x 13 3/8 inches (paper)
 Signed in lower left: PEARSON 1960
 Promised gift of Terry and Ed Duffy
 (Page 53)

22. Untitled, 1960
 Ink on paper
 6 x 11 1/4 inches (image)
 10 x 13 5/8 inches (paper)
 Signed in lower left: PEARSON 1960
 Promised gift of the artist
 (Page 53)

23. Untitled, 1960
 Ink on paper
 4 3/8 inches diameter (image)
 7 3/16 x 5 3/8 inches (paper)
 Signed in lower left: PEARSON 1960
 Promised gift of Terry and Ed Duffy
 (Page 54)

24. Untitled, 1960
 Ink and watercolor on paper
 4 inches diameter (image)
 8 1/8 x 5 15/16 inches (paper)
 Signed in lower left: PEARSON 1960
 Promised gift of the artist
 (Page 36)

25. Untitled, 1960
 Ink on paper
 14 13/16 x 14 13/16 inches (image)
 19 7/8 x 19 7/8 inches (paper)
 Signed in lower left: PEARSON 1960
 Promised gift of the artist
 (Page 55)

26. Untitled, 1962
 Ink on paper
 11 1/2 inches diameter (image)
 15 5/8 x 19 7/8 inches (paper)
 Signed in lower left: PEARSON 1962
 Promised gift of the artist
 (Page 56)

27. Untitled, ca. 1963
 Ink and graphite on paper
 8 inches diameter (image)
 13 15/16 x 9 15/16 inches (paper)
 Signed in lower right: PEARSON
 Promised gift of the artist
 (Page 57)

28. Untitled, ca. 1963
Ink and graphite on paper
11 13/16 x 15 3/8 inches (image)
15 3/8 x 19 7/8 inches (paper)
Promised gift of the artist
(Page 58)

29. Untitled, 1964
Ink on paper
9 1/4 x 18 inches
Signed on verso, in lower left: PEARSON and with
 monogram in lower right: HP 1964
Promised gift of the artist
(Page 59)

30. Untitled, ca. 1964
Ink and graphite on paper
6 1/8 x 9 3/16 inches (image)
8 1/16 x 12 1/8 inches (paper)
Promised gift of the artist
(Page 59)

31. *Black Sun*, 1965
Ink on paper
15 5/8 x 20 1/4 inches
Signed lower right: PEARSON 1965
Promised gift of the artist
(Page 60)

32. Untitled, 1966
Ink and watercolor on paper
ca. 5 3/4 x 7 inches (image)
9 1/16 x 12 3/16 inches (paper)
Signed in lower right: PEARSON 1966
Promised gift of the artist
(Page 36)

33. Untitled, 1966
Ink and watercolor on paper
4 3/8 inches diameter (image)
6 7/16 x 6 3/16 inches (paper)
Signed in lower right: PEARSON 1966
Promised gift of the artist
(Page 36)

34. Untitled, 1966
Ink and watercolor on paper
4 7/16 inches diameter (image)
7 11/16 x 7 1/2 inches (paper)
Signed in lower right: PEARSON 1966
Promised gift of the artist
(Page 37)

35. Untitled, ca. 1966
Ink, graphite, and watercolor on paper
7 1/4 inches diameter (image)
9 x 12 3/16 inches (paper)
Promised gift of the artist
(Page 37)

36. Untitled, 1966
Ink and watercolor on paper
9 x 12 3/16 inches
Promised gift of the artist
(Page 37)

37. Untitled, 1966
Ink and watercolor on paper
9 x 12 3/16 inches
Signed in lower right: Pearson 1966
Promised gift of the artist
(Page 38)

38. Untitled, 1966
Ink and watercolor on paper
12 x 16 inches
Signed in lower right: Pearson 1966
Promised gift of the artist
(Page 38)

39. *#4 1967*
Ink and watercolor on paper
12 1/16 x 10 1/8 inches
Promised gift of Terry and Ed Duffy
(Page 39)

40. *Crucible I*, 1967
Ink and watercolor on paper
15 x 15 inches
Signed in lower right: Henry Pearson 1967
Promised gift of the artist
(Page 40)

41. *T.E.E.M. Ball*, ca. 1967
Ink on papier-mâché mounted on aluminum
20 inches diameter
Promised gift of Terry and Ed Duffy
(Page 61)

42. *Masque of David II*, 1968
Ink on cast plaster
ca. 4 7/8 x 6 1/2 x 2 1/2 inches
Signed on verso: PEARSON 1968
Promised gift of Terry and Ed Duffy
(Page 62)

43. Study No. I for Lincoln Center New York Film
 Festival Poster, 1968
 Ink and graphite on paper
 22 7/8 x 15 inches (image)
 23 7/8 x 16 1/4 inches (paper)
 Promised gift of the artist
 (Page 63)

44. Study No. II for Lincoln Center New York Film
 Festival Poster, 1968
 Ink and graphite on paper
 22 7/8 x 15 1/8 inches (image)
 23 1/16 x 15 7/16 inches (paper)
 Promised gift of the artist
 (Page 64)

45. Untitled, 1969
 Ink and watercolor on paper
 17 1/16 x 14 1/16 inches
 Signed in lower right: Henry Pearson '69
 Promised gift of the artist
 (Page 41)

46. *Sagittarius XI (Kamo Ascension I)*, 1969
 Ink and watercolor on paper
 9 1/16 x 9 1/16 inches
 Signed on verso in middle right:
 Henry Pearson 1969/ "SAGITTARIUS XI"/
 "(KAMO ASCENSION I)"
 Promised gift of the artist
 (Page 42)

47. Untitled, 1969
 Ink and watercolor on paper
 9 x 9 inches
 Promised gift of the artist
 (Page 42)

48. *Angular Deviation #15*, 1969
 Ink and watercolor on paper
 13 13/16 x 19 7/8 inches
 Promised gift of Terry and Ed Duffy
 (Page 43)

49. Untitled, ca. 1974
 Ink and graphite on paper
 6 1/16 x 9 1/8 inches (image)
 8 1/16 x 11 3/4 inches (paper)
 Promised gift of the artist
 (Page 65)

50. Untitled, 1975
 Ink and watercolor on paper
 10 x 8 1/16 inches
 Signed on verso in lower right: Henry Pearson 1975
 Promised gift of the artist
 (Page 44)

51. *Ethical Movement II*, 1982
 Ink on paper
 14 1/8 x 17 1/8 inches
 Signed in lower right: PEARSON 1982
 Promised gift of Terry and Ed Duffy
 (Page 66)

52. *1976/5*
 Vinyl and Conté crayon on paper
 13 7/8 x 17 1/8 inches
 Signed in lower right: Pearson 1976/5
 Promised gift of the artist
 (Page 45)

53. *1976/14*
 Vinyl, Conté crayon, and ink on paper
 13 7/8 x 17 1/8 inches
 Signed in lower right: Pearson 1976/14
 Promised gift of the artist
 (Page 45)

54. Untitled, 1976
 Acrylic and ink on paper
 23 x 17 inches
 Promised gift of Terry and Ed Duffy
 (Page 46)

55. *Genesis 18:2*, 1979
 Ink and watercolor on paper
 ca. 4 13/16 x 6 1/2 inches (image)
 5 15/16 x 8 15/16 inches (paper)
 Signed in lower left: PEARSON 1979 and in left
 margin: GENESIS 18:2
 Promised gift of Terry and Ed Duffy
 (Page 47)

56. *Genesis III:1-6*, 1979
 Ink, watercolor, and vinyl on paper
 7 7/16 x 7 7/8 inches (image)
 8 15/16 x 9 7/16 inches (paper)
 Signed in lower left: PEARSON 1979 and in
 extreme lower left: GENESIS III: 1-6
 Promised gift of Terry and Ed Duffy
 (Page 47)

57. *Judgement of Paris with 1924 Lagonda*, 1979
 Ink, watercolor, and vinyl on paper
 7 1/2 x 8 5/8 inches (image)
 8 15/16 x 10 inches (paper)
 Signed in lower left: PEARSON 1979
 Promised gift of Terry and Ed Duffy
 (Page 48)

58. *Hercules and Antaeus*, 1979
 Ink, watercolor, and vinyl on paper
 7 3/8 x 6 3/8 inches (image)
 8 15/16 x 8 inches (paper)
 Signed in lower left: PEARSON 1979
 Promised gift of Terry and Ed Duffy
 (Page 48)